STILL LIFE WITH OYSTERS AND LEMON

STILL LIFE WITH OYSTERS AND LEMON

MARK DOTY

Beacon Press Boston

Beacon Press
25 Beacon Street
Boston, Massachusetts 02108-2892
www.beacon.org

Beacon Press books
are published under the auspices of
the Unitarian Universalist Association of Congregations.

Printed in the United States of America

27 26 25 24 23 24 23 22 21

This book is printed on acid-free paper that meets the uncoated paper
ANSI/NISO specifications for permanence as revised in 1992.

Text design by Sara Eisenman
Composition by Wilsted & Taylor Publishing Services

Library of Congress Cataloging-in-Publication Data

Doty, Mark.
Still life with oysters and lemon / Mark Doty.
p. cm.
ISBN 978-0-8070-6609-6 (pbk.)
1. Doty, Mark. 2. Poets, American—20th century—Biography. 3. Painting.
I. Title.
PS3554.O798 Z474 2001
811'.54—dc21
[B] 00-040397

for Robert Jones

. . . life which is so fantastic cannot be altogether tragic.

Virginia Woolf

STILL LIFE WITH OYSTERS AND LEMON

A sharp cracking cold day, the air of the Upper East Side full of rising plumes of smoke from furnaces and steaming laundries, exhaust from the tailpipes of idling taxis, flapping banners, gangs of pigeons. Here on the museum steps a flock suddenly chooses to take flight, the sound of their ascent like no other except maybe the rush of air a gas stove makes, when the oven suddenly ignites, only with the birds that sudden suck of air is followed by a rhythmic hurry of wings that trails away almost immediately as the flock moves into the air. Their ascent echoes back from the solidity of the museum's columns and heavy doors, the wide stairway where even in the cold people are smoking and shifting their chilly weight from side to side, eating pretzels, hunching over blue and white paper cups of coffee.

I have a backache, I'm travel weary, and it couldn't matter less, for this whole scene—the crowd and hustle on the museum steps, which seem alive all day with commerce and hurry, with gatherings and departures—is suffused for me with warmth, because I have fallen in love with a painting. Though that

phrase doesn't seem to suffice, not really—rather's it that I have been drawn into the orbit of a painting, have allowed myself to be pulled into its sphere by casual attraction deepening to something more compelling. I have felt the energy and life of the painting's will; I have been held there, instructed. And the overall effect, the result of looking and looking into its brimming surface as long as I could look, is love, by which I mean a sense of tenderness toward experience, of being held within an intimacy with the things of the world.

That sense has remained with me as I moved out through the dark stone lobby of the museum, with its huge vase of flowers looming over the information desk in the center of the room, and out into the sudden winter brightness—the gray brightness of Manhattan in January—onto the museum steps. There, stepping outside into the day, where nothing is framed or bounded as things in the museum are, suddenly the sense of intimacy and connection I've been feeling flares out, as if my painting had been a hearth, a heated and glowing place deep in the museum interior, and I'd carried the warmth of it with me out into the morning. Is it morning still? The sky's a huge crystal, cracked and alive with fractures, contrails, cloudy patches, huge distances.

But nothing seems truly remote to me, no chill too intractable. Because I have stepped from a warm suspension out into the shatteringly cold air, something of that suspension remains within me, or around me. It is the medium in which I and my fellow citizens move. We are all moving, just now, in the light that has come toward me through a canvas the size of a school notebook; we are all walking in the light of a wedge of lemon, four oysters, a half-glass of wine, a cluster of green grapes with a few curling leaves still attached to their stem. This light is

enough to reveal us as we are, bound together, in the warmth and good light of habitation, in the good and fleshly aliveness of us.

How is it possible?

It's a simple painting, really, *Still Life with Oysters and Lemon*, by one Jan Davidsz de Heem, painted in Antwerp some three hundred and fifty years ago, and displayed today—after who knows what places it has been—in a glass case at the Metropolitan, lying flat, so that one bends and looks down into its bronzy, autumnal atmosphere. Half-filled *roemer* (an old Dutch drinking glass, with a knobby base) with an amber inch of wine, dewy grapes, curl of a lemon peel. Shimmery, barely solid bodies of oysters, shucked in order to allow their flesh to receive every ministration of light. It *is* an atmosphere; the light lovingly delineating these things is warm, a little fogged, encompassing, tender, ambient. As if, added to the fragrance evoked by the sharp pulp of the lemon, and the acidic wine, and the salty marsh-scent of the oysters, were some fragrance the light itself carried.

Simple, and yet so firm in its assertions.

I'll try to name them.

That this is the matrix in which we are held, the generous light binding together the fragrant and flavorful productions of vineyard, marsh, and orchard—where has that lemon come from, the Levant?

That the pleasures of what can be tasted and smelled are to be represented, framed, set apart; that pleasure is to be honored.

That the world is a dialogue between degrees of transparency—globes of the grapes, the wine in the glass equally penetrated by light but ever so slightly less clear than the vessel itself, degrees of reflectivity.

That the world of reflection implicates us, as well—there, isn't that the faintest image of the painter in the base of the glass, tilted, distorted, lost in the contemplation of his little realm? Looking through things, as well, through what he's made of them, toward us?

That there can never be too much of reality; that the attempt to draw nearer to it—which will fail—will not fail entirely, as it will give us not the fact of lemons and oysters but this, which is its own fact, its own brave assay toward what is.

That description is an inexact, loving art, and a reflexive one; when we describe the world we come closer to saying what we are.

And something else, of course; there's always more, deep in art's pockets, far down in the chiaroscuro on which these food-stuffs rest: everything here has been transformed into feeling, as if by looking very hard at an object it suddenly comes that much closer to some realm where it isn't a thing at all but something just on the edge of dissolving. Into what? Tears, gladness—you've felt like this before, haven't you? Taken far inside. When? Held. Maybe that's what the darkness behind these things, that warm brown ground, is: the dark space within an embrace.

Intimacy, says the phenomenologist Gaston Bachelard, is the highest value.

I resist this statement at first. What about artistic achievement, or moral courage, or heroism, or altruistic acts, or work in the cause of social change? What about wealth or accomplishment? And yet something about it rings true, finally—that what we want is to be brought into relation, to be inside, within. Perhaps it's true that nothing matters more to us than that.

But then why resist intimacy, why seem to flee it? A powerful

countercurrent pulls against our drive toward connection; we also desire individuation, separateness, freedom. On one side of the balance is the need for home, for the deep solid roots of place and belonging; on the other is the desire for travel and motion, for the single separate spark of the self freely moving forward, out into time, into the great absorbing stream of the world.

A fierce internal debate, between staying moored and drifting away, between holding on and letting go. Perhaps wisdom lies in our ability to negotiate between these two poles. Necessary to us, both of them—but how to live in connection without feeling suffocated, compromised, erased? We long to connect; we fear that if we do, our freedom and individuality will disappear.

One would not expect to turn to still life for help with these questions. But I think of the familiar phrase about there being "more than meets the eye"; in these paintings, the "more" *does* meet the eye; they suggest that knowledge is visible, that it might be seen in the daily world. They think, as it were, through things.

In my Jan Davidsz de Heem, for instance, there is a spectacular spiral of lemon peel, a flourish of painterly showing-off. The rind has been sliced in a single strip, and it curls in the air, resting atop the *roemer;* one of its coils dips inside, toward the wine, so that we see it now plainly, now veiled by the slightly gray cast of the glass. Now the pebbly yellow, as it twists through air, now the white pith that lay between that outer skin and the body of the fruit. Shadows lie in the twisting helix, in the curling hollows—like the socket of an armpit, or the hollows at the base of the neck, the twin wells of the collarbone. These are fleshy, erotic shadows, and they stand in contrast to the brilliance raking across the peel, cut so thin as to be translucent, a slice of the warmth and energy pouring into this room we'll never see.

This is by no means the only bravura lemon in Dutch paint-ing of the seventeenth century. They are, in fact, everywhere, in pictures by Pieter de Ring, Abraham van Beyeren, Willem Kalf, Jan Jansz den Uyl, and Adriaen van Utrecht, to name just a few. These lemons seem to leap to the foreground; the stippled, tex-tured surface of the paint—noticeably thickened beside the glazed surface used elsewhere for silver cups and pewter plates, or bowls of porcelain—gives the eye a focal point and therefore makes the peel appear closer to us.

They are, in a way, nudes, always in dishabille, partly un-draped, the rind peeled away to allow our gaze further plea-sure—to see the surface, and beneath that another surface. Often the pith is cut away as well, the fruit faceted so that we can see its wet translucence, a seed just beneath, and sometimes another seed or two is tossed to the side of the plate on which this odalisque rests, diminutive seeds just as precise as the fruit and its pulpy sections; nothing is too tiny for the attentive eye.

The lemons are built, in layers, out of lead tin yellow, which the Italians called *giallo di Fiandria,* a warm canary made by heating lead and tin oxides together, which was also the pre-ferred pigment for the petals of daffodils, and out of *luteolum Neapolitanum,* or Naples yellow, and of a glowing but unstable pigment called orpiment. Often these colors are glazed with yel-low glazes made of broom or berries. Alchemists' work, turning tin and arsenic and vegetable juices into golden fruit painted with a kind of showy complication and variety that suggests there must have been competition among the painters of lem-ons. How to paint a lemon with a freedom and inventiveness that sets it apart? Jacob von Hulsdonck specialized in citrus par-tially ripe, the stippled surface of the fruit blushed with that acidy green which indicates the peel's only recently yellowed. Whose half-peeled fruit could be most complexly faceted, like a

gemstone, in order to reveal nuances of transparency and re-
flectivity, the seeds resting within the revealed sections? Who
could give the coiled peel the greatest sense of heft and curve, or
spiral it down from the edge of a table, with the most convinc-
ing sense of gravity's pull? In Cornelis de Heem's *The Flute of*
Wine, a swoop of lemon peel occupies the very center of the pic-
ture, looping down into the space below the edge of the table
and back up again to end in a flourish of curl, impossibly long,
as if the little fruit had yielded an unlikely bounty of peel to
serve the painter's purposes. Whose peel could be cut the thin-
nest, barely there at all, a translucent yellow interruption in the
air?

In another canvas of Jan Davidsz de Heem's, the lavishly
wealthy *Nautilus Cup with Silver Vessels,* the painter seems to
strut, to take the lemon competition as far as it might reason-
ably go, even a little farther. Here a strip of peel is shown alone,
detached from its fruit, at the corner of a table shrouded in a
dark cloth. The peel coils intricately, impossibly—a baroque bit
of ribboning made to show us exactly what this painter could
do.

Lemons: all freedom, all ego, all vanity, fragrant with scent
we can't help but imagine when we look at them, the little
pucker in the mouth. And redolent, too, of strut and style. Yet
somehow they remain intimate, every single one of them: only
lemons, only that lovely, perishable, ordinary thing, held to
scrutiny's light, fixed in a moment of fierce attention. As if here
our desire to be unique, unmistakable, and our desire to be of a
piece were reconciled. Isn't that it, to be yourself and somehow,
to belong? For a moment, held in balance.

To think through things, that is the still life painter's work—
and the poet's. Both sorts of artists require a tangible vocabu-

lary, a worldly lexicon. A language of ideas is, in itself, a phantom language, lacking in the substance of worldly things, those containers of feeling and experience, memory and time. We are instructed by the objects that come to speak with us, those material presences. Why should we have been born knowing how to love the world? We require, again and again, these demonstrations.

My first resonant, instructive thing?

Hypnotist's wheel, red swirl blazoned on a hard white candy ground, spinning even when it isn't moving; that's the life of the spiral, it seems to whirl even when it's at rest. Peppermints, each wrapped in a a shiny square of cellophane which twists at the ends into little flourishes. They emerge, one after the other, endless, pouring out; perhaps they come into being the way matter is said to do, from the collapsed bodies of dead stars, streaming out into the world. But the dark from whence they emerge is the unfathomable void of my grandmother's glossy black pocketbook.

Her name is Lona, though I don't know that, and won't for years. Because this is East Tennessee, in the second half of the nineteen fifties, she is called Mamaw, and that's the only name I have ever called her.

Mamaw wears a thin flowered dress of rayon or some other slippery stuff, and a white crocheted cardigan sweater, also thin, that keeps riding up her skinny, intricately mottled wrists; the sleeves of her sweaters are never long enough, and somehow this underlines the fact that everything about her is thin, both delicate and peculiarly sturdy at once.

Those wrists are a wonder: veins and splotches, just at the back of the hand, rhyme with her liver-colored "age spots." To-

gether we've heard a commercial on her radio for a cream that

claimed to make them fade and then *vanish* (magician's verb: something pops out of sight, out of being, like a silver dollar or a dove). The adjective the radio chose for the spots was "horrid": interesting clear sound, immediately calling up, for some reason, a chain of scents—vomit, calamine lotion, peculiar odor of a cigar box filled with rubber bands, girdle folded in a drawer.

When Mamaw stands up with the sun behind her you can see through the dress to her legs, and I am the perfect height to study the outline of the elastic stockings she wears, folded over at the top into a kind of cuff, which makes a darker band beneath her knees. My grandfather wears these, too; they seem part of a vocabulary of age, one of the assembly of items binding what would otherwise sag or separate or fall: elastic things, rubber things, corsets and belts and lifts, stays and trusses. All tend toward the beige region of the spectrum, and though they are called "flesh" they're the color of no one's skin, but the hue of mannequins or dolls. Beneath her stockings are thick black shoes; their chunky short heels bear the hallmark of necessity rather than style.

Her ensemble is completed by the pocketbook; the word seems as capacious and black as the thing it represents, which is square, shiny, carried by a double strap, and closed with an irresistible pair of prongs that must be snapped one over the other, so that the pocketbook opens and closes with a satisfying click: slight reverberation of metal, the nice feel of fingers firm against patent leather.

What can't the pocketbook contain? Certainly it holds far more than I know; it is not for me to delve into its contents, many of which I doubtless couldn't name if I saw them. But she brings things up and into the light as they are needed, or simply

in order to entertain with their startling variety. Which includes a plastic rain bonnet of see-through vinyl that folds up, growing increasingly opaque as it is doubled and tripled into a tiny rectangle and slipped into a plastic envelope. A paper fan, the stiff oblong sort printed with a religious picture and mounted on a wooden handle. These change periodically as new ones are provided in church, but this week's scene—the week we are going to see the bears!—pictures Jesus in the garden of Gethsemane. His face turned upward, long hair flowing, he kneels at a convenient stone, pale countenance tilted toward the moon. Or is he suffering the children to come unto him? Maybe it's Easter, and everything is lilies and lilies. Whatever the case, there is more: an exquisite little change purse, whose labial folds increase to catch and sort coins, its top sealed by another of those tempting closures. Doan's Pills. Lavender water. Smelling salts in a tiny glass ampule, to be broken when absolutely needed. Round tin of snuff, since she likes the occasional pinch. A tiny red edition of the New Testament, tissues in small packets, a sparkly pair of multifaceted earrings whose clasp has long ago broken; short, dull-tipped pencils; a cluster of the ubiquitous, potentially useful rubber bands; a scrap of ribbon snipped from the flowers at whose grave? And then, the item to which my attention is repeatedly drawn, to which all the other items are merely ancillary: those red, pinwheeled peppermints.

We're in the backseat of the green Studebaker, driving to see the bears. It isn't a long drive, really, from our house up into the Smokies, but, heavens, the preparations and consideration, the work of getting everyone ready for the Sunday drive. I am in the backseat with my grandfather, who has his cane standing upright between his legs and is wearing a brown felt fedora with a black ribbon above the brim. And then me, in the middle, though I do not turn toward him but toward Mamaw, who has

the window seat (as well as a cardboard box from the store in which she last bought one of those flowered dresses) in case of car sickness. She has a brown paper sack containing pears, some pieces of fried chicken individually wrapped in foil, her Geritol, and a quantity of triangular sandwiches, consisting of nothing but butter on white bread. These she loves. For me there is apple butter, dark and resinous, on the same white triangles—like little sails or game pieces.

Memory, which has so thoroughly costumed and illuminated the aspect of the old woman to my right, has not had resources left over to do much with the rest of that automobile's interior. My father's driving; my sister is beside him, probably thirteen or fourteen, and the metal bar dividing the windshield in half seems to spring right out of the center of her blond head; my mother is in the right-hand half of the view. Certainly there is discussion, perhaps songs, does someone turn from the front seat to the back and tell me to be still? No narrative here, but suddenly we're in Gatlinburg, whose salient feature is bears: little stuffed black bears, toys the size of my head or my paired hands, each wearing a vest or belt of red vinyl. They are lovable in their multiplicity, rows and rows of bears hanging from shelves, porch rails, the sides of tables of souvenirs: snow globes, ashtrays, thermometers, salt and pepper shakers, plaques of sliced and varnished wood with mottoes inscribed beneath the glaze. Boxes of candy, shaped like leaves or snowflakes. I want a bear.

Which I cannot have, because we are going on to see the real bears. The mountains are pale blue, in memory, like those misty and indeterminate landscapes in the backdrops of Leonardos; we are driving and driving on curving roads, we are stopping for vistas, we are lined up and photographed, in my face that lingering regret for the embraceable entity of the furry black toy with

its vinyl vest and its small and friendly gaze. Then we are parked at a turnout, on the side of the high, two-lane road, not on the slope side, which is all air and distance, but on the side where the trees are, cool and towering, and out of the dark spaces between the pines have come the bears. They are walking toward us, coming on all fours in a scamper or standing up, on two legs, a bit less gracefully, lumbering a little, but their faces are open and eager; they are coming to see us, and suddenly I know I have been so lonely. That is why I wanted my parents to buy me that small bear; I wanted to embrace the animal, wanted to carry the lustrous black beast in my arms, sit him beside me on the car seat. And now, I think, I want to live with the bears, want to be back in their company—why "back"? Was I in their company sometime before? It seems like a homecoming, to be with them, and maybe Mamaw feels it too, which is why she opens the pocketbook and produces the beautiful candies and lays them out on the low stone wall that marks the border between the turnout and the woods. Does she unwrap the peppermints? I can't recall—only the red swirls set out on the rough surface of the piled stones, and the gesture of her hand reaching down into invisibility and coming up with two or three of the little pinwheels and holding them out toward the eager black faces drawing nearer.

And soon we were in the car, all of us, with the windows closed, and the tall figures standing around us, rocking back and forth a little, their forepaws raised in the air, their tongues touching their teeth and lips, and Mamaw was still rummaging in her pocketbook saying, *There must be more in here somewheres.*

In memory's theater, those years are restored and distilled. Here is a plain table, laid out in a space dark as the interior of the

pocketbook. A curtain's hung behind it, perhaps to indicate that behind these visible things—each set particularly, lovingly, in the light of recollection—is a boundary, a veil. What we can see of the lost world is exactly this: little vials of medicine, a tall, slender bottle of a dark tonic (*Remember,* says the voice of a distant announcer in my head, *Serutan is Nature's spelled backwards.* Isn't all space full, by now, of broadcast voices, intoning their slogans and pitches and absurd fragments of human speech? Has our babble penetrated as far out into space as it has within?). And here are all the beautiful contents of my Mamaw's purse, each laid out, barely touching the other, each made poignant with distance and time. Here in the center, in a footed silver dish brought back by one of my aunts who was a missionary in Korea, a cheerful dragon circling its rim, the peppermints anchor and glow, sparkling in their little skins of cellophane.

I have friends who actually own a painting that feels like this, a panel from the seventeenth century. A physical fact, historic, material, but still like my construction made of memory in that it represents a poetic field of objects arrayed against the dark, things somehow joined in a conspiracy of silence, some whispered communion between them, a dialogue we cannot hear. An old, collegial conversation, taking place not in the time of earth, from which these things have been plucked, but in the time of art, which is a little nearer to the time of eternity than our poor daily gestures. Unlikely circumstance, it seems to me, to possess such a picture, like owning a mountain or a great public building. How strange to own such a compressed vision of domestic interiority, such an artifact of intimacy. A vessel of feelings whose subject has long since vanished, but which remains, a fixed distillation of emotion.

The painting is by Osias Beert, and it dates from early in the great century of Dutch still life. Beert died in 1623, when the

conventions of the genre were just being articulated. And so in his paintings—which are performed in inky browns and blacks and lustrous grays—dishes are always arrayed on a table arranged horizontally before us, a single, simple plane. The table extends on both sides beyond the edge of the canvas; behind it is only darkness, and arranged in each of these pictures are repeated elements Beert must have been fond of, and felt he'd mastered: a shallow bowl, of Chinese porcelain produced in the Wan-li reign of the Ming dynasty; a footed, elaborately chased silver dish filled with intricate little candies, white and spiny as shards of coral. Some delicate beakers of wine. A simple pewter chaser, usually displaying a clutch of halved oysters.

When it came to oysters, Osias Beert had no peer, I think. In the National Gallery of Art in Washington there is a platter of his oysters that seems the ultimate expression of light playing on the slightly viscous, pearly, opalescent, and convoluted flesh, its wetness distinguishing it from the similarly sheened but hard stuff of the shells' interior. Their liquidity makes me want language to match, want on my tongue their deliquescence, their liquefaction. Beert's is a demonstration of virtuosity so extreme as to be explicable only by means of love: this is a testament of falling in love with light, its endless variation, its subtlety and complexity. I try to imagine coming to this kind of knowledge, a very specific, long practice of perception alloyed with a knowledge of materials—how to commingle oils and pigments just so, to the right texture, how to apply them in particular layers so as to translate this knowledge of the appearance of a particular gleam into paint. It is a sort of knowledge that must be wordless, incommunicable, so precisely does it depend upon a long context of looking and practice, and so specific is its aim. I doubt it is something anyone has done before, or will again; perhaps no one wants to, really. There is neither willing nor accounting for

such a love, a passion perfected through discipline and obsession—and perennially demonstrated by this ravishing, transfixing platter of shellfish.

Which do not appear in my friends' Beert, an odd and poignant painting—bowls of cherries, of sweetmeats, of berries, a *roemer* of wine, characteristically arranged on that wooden table so that they hardly overlap, as if we're meant to see each thing singularly. Therein lies a large portion of the painting's poetry; these things form not a single whole but a concert, a community of separate presences; we are intended to compare their degrees of roundness, solidity, transparency, and opacity. They are each a separate city, a separate child in a field of silent children. They speak back and forth—do they?—across the distance between them. At dinner at my friends', I was seated with my back to the painting, but I felt its magnetism; I was trying to converse, I was conversing, but I felt still its pull, the strange silence of these separate things refusing to form a singular composition, as if it were my work to complete them, as if they needed and demanded me. The wineglasses at our table rose above the white tablecloth into the brightly lit space between us; in the painting, the wineglass rose up against a field of lustrous gloom, its contents merging with the dark.

Because this painting has never been restored there is a heightened poignance to it somehow; it doesn't have the feeling of unassailable permanence that paintings in museums do. There is a small crack in the lower left, and a little of the priming between the wooden panel and the oil emulsions of paint has been bared. A bit of abrasion shows, at the rim of a bowl of berries, evidence of time's power even over this—which, paradoxically, only seems to increase its poetry, its deep resonance. If you could see the notes of a cello, when the bow draws slowly and deeply across its strings, and those resonant reverberations

which of all instruments' are nearest to the sound of the human voice emerge—no, the wrong verb, they seem to come into being all at once, to surround us, suddenly, with presence—if that were made visible, that would be the poetry of Osias Beert.

But the still life resides in absolute silence.

Portraits often seem pregnant with speech, or as if their subjects have just finished saying something, or will soon speak the thoughts that inform their faces, the thoughts we're invited to read. Landscapes are full of presences, visible or unseen; soon nymphs or a stag or a band of hikers will make themselves heard.

But no word will ever be spoken here, among the flowers and snails, the solid and dependable apples, this heap of rumpled books, this pewter plate on which a few opened oysters lie, giving up their silver.

These are resolutely still, immutable, poised for a forward movement that will never occur. The brink upon which still life rests is the brink of time, the edge of something about to happen. Everything that we know crosses this lip, over and over, like water over the edge of a fall, as what might happen does, as any of the endless variations of what might come true does so, and things fall into being, tumble through the progression of existing in time.

Painting creates silence. You could examine the objects themselves, the actors in a Dutch still life—this knobbed beaker, this pewter salver, this knife—and, lovely as all antique utilitarian objects are, they are not, would not be, poised on the edge these same things inhabit when they are represented. These things exist—if indeed they are still around at all—in time. It is the act of painting them that makes them perennially poised, an emergent truth about to be articulated, a word wait-

ing to be spoken. Single word that has been forming all these years in the light on the knife's pearl handle, in the drops of moisture on nearly translucent grapes: At the end of time, will that word be said?

When my Mamaw died, which cannot have been so very long after our visit to the bears, my grandfather was shipped off to live with another of his children, and I was given my grandparents' old room. She had died in the night, in that room, flinging the window open and calling for more air, poking her head out the window into the chilly winter night even though she wore just a nightgown, convinced that there wasn't enough air inside the house to satisfy her and that she needed a deep cold breath to fill her lungs.

I was four or five; this was my first death. She herself had filled my head with religious depictions of the afterlife, the next world, a deeper and truer world behind this one, where we would dwell when the veil was lifted. She was a fountain of imagery, both from songs and from scripture, which she used to read to me while I dreamed in her lap in the swaying of her green rocking chair. We listened to Oral Roberts together on the radio; we drank the pure clear waters of the Living Word. (Somewhere—on television, at the fair—didn't we see something called the Dancing Waters? A display of fountains, playing in colored lights, rising and falling, wonderful in name and in anticipation but disappointing in actuality?) For her, all the visible world was a veil thin as the slippery fabric of her dresses, or the Dancing Waters' clear and mobile jets. Last Days, End Times; the world before us was all about to be swept away.

But she was swept away instead, and however this was described to me—gone home to Jesus, there among the lilies, already in heaven, a bright and shining star—there was also the

fact of my father crying at her funeral, something I had never before seen him do, and the odd waxen presence of her, in her pleated lavender shroud, eyes sunken and closed, utterly and deeply still among the gladioli. If I could have described how I felt about all this, I believe I would have said that the strangeness of her body's arrest and disappearance was what occupied my attention most. Though what began to occupy my imagination shortly thereafter was her room. There was her presence and her absence all at once. Now it was my room. Had I ever had a room? I think not. I am aware of the height of the ceiling, the dark of the wooden bedstead and bureau, the green rocker empty now, a strange pleasure in the prospect of occupation. My mother helps me to ready the room; there are only a few things of Mamaw's left here, Bible and rocker and a store of rubber bands—dresses and old church hats and the white cardigan have been taken away, along with the store of old pocketbooks, supply of paper fans—and now we are engaged in making something new, which partakes of the old but is also now my space, what I will occupy. In Sunday school I've learned to make ships, little paper ones, and I have named them for the three ships Columbus sailed, the *Niña,* the *Pinta,* and the *Santa María.* I place them sailing across a crocheted bureau scarf—something that must have been Mamaw's—as if the knotted cotton were sea foam, and the dark oak were the ocean across which these travelers set out. These are the focus of the room—in my memory, at least, a green room, walls the color of the green of cantaloupe rind, though maybe what I remember is the color of light through old green window shades filtering the sunlight into the room my mother and I are claiming as mine.

This was my first intimation that style had something to do with death.

At first still life seems so entirely of this world—a clarification and celebration of what is—that it can have little to do with mortality. But in truth, the secret subject of these paintings is what they resist. What they deny is also the underlying force, more potent than lead or tin or orpiment, that makes these lemons glow with life.

Everything in the field of our vision is passing. And some of these things will be here just the briefest while; these opened oysters, this already-spotted quince are right at the edge of corruption even as we catch sight of them.

And yet, in the suspension these paintings, they will fade no more slowly than the hobnailed glass *roemer,* or this heap of rifled books; everything floats on this brink, suspended above the long tunnel of disappearance. Here intimacy seems to confront its opposite, which is the immensity of time. Everything—even a painting itself—is evanescent, but here, for now, these citizens of the great community of the disappearing hang, for a term, suspended.

There is a poignant and beautiful picture in the Rijksmuseum by Martinus Nellius, a dark and atmospheric piece called *Still Life with Quinces, Medlars and a Glass.* It has a peculiar warmth, its few elements emerging from a deep darkness as some soft, unifying source of light binds them together: two small medlar apples, a beechnut, an opened walnut, two large yellow quinces, a quarter of a pomegranate, all eaten save for this remaining section, some drying leaves plucked with the quinces, and tall in the background, a simple, delicate Venetian glass, a flute half-filled with red wine. Warm yellow, madder, ocher, garnet, all against a brown dark. It must have been an emotive painting to begin with; some lamp-shine of intimacy

fires the whole thing, some sense of autumnal community, harvest-ripe and complete, the season moving to an ending.

Yet the painting is even more moving now, because on the large quince, where a single fly is poised—reminder of the mellowness of these fruits, the lovely moment on the cusp of dissolution—is visible a strange kind of powdery whiteness. The restorer's text notes "a somewhat crumbly texture. The cross section of this paint shows that the yellow pigment has a rather cloudy appearance at the surface."

The glow of this fruit was achieved with the bright and lemony mineral orpiment, which, ground in an oil medium, produced a live, golden tone. The arsenic sulphide it contains has undergone a kind of chemical transformation caused by three hundred years of exposure to light; the sulphide's become an oxide, in the process releasing a corrosive gas, breaking up the linseed oil and tree resins that bound the pigment in place. And so the paint of the quince has crumbled, at the surface, breaking Nellius's illusion, and making the sweet autumn sheen of his painting—brandy-warm, tinged with smoke and the scent of ripe leaves—that much sadder and that much more alive.

When I was nineteen, something of Mamaw returned to my life, in the form of another old woman, one whom I met only once, for a few days, in the summer of 1972. Bertha Cudd was my new wife's mother, and she lived in Boyce, Louisiana, the town where she'd spent her entire life. From the moment I walked into her house—into the high-ceilinged long hallway that ran all the way through the center of the place, where above a dark mahogany table hung a sepia print of Jesus kneeling at that same rock, those same long locks curling back over his shoulders as he turned his face toward the night sky in which he

seemed to expect to see the face of his father—I was home. It
was partly that familiar image, which carried so much of Ma-
maw with it, and of the gone world of East Tennessee I'd left be-
hind as a child, when my parents and I moved away. But it was
also the smell of the house, a subtle compound of the musty in-
sides of drawers or the mildewing edges of old prints sealed in
their heavy frames, and furniture polish, and PineSol, and rose-
water, or odd bits of sachets stuffed into drawers, and of the sort
of inexpensive bottles of scent favored by old country ladies,
perhaps the tang of it smoked a little by the faint back-odor of
bacon grease, too. I would like to have that scent now, in a
bottle; I would like to be able to breathe it at will and return to
that lost atmosphere. Is it still out there, in the houses of old
women somewhere?

Bertha herself was at the far end of the hallway, bent over the
sink in a little bathroom whose opened door framed her, wigless
and bald as she was born. She was putting in her teeth, pre-
paring for our visit, and was so happy to see us that she quite for-
got the wig and came storming forth from the back of the house,
her stringy old arms spread wide, tears streaming down those
mottled cheeks, and as soon as she had greeted us, saying she
was truly blessed, and that what she had wanted was to see her
daughter again before she died, and see her daughter happy—
she remembered the wig. *Oh, I have lost every hair on my head,*
she cried, and hurried to don the crooked gray frill of a thing,
and then hurried back to usher us into the high-ceilinged old
kitchen to sit at the table while she set to making coffee, warm-
ing biscuits, bringing forth jars of jam, attending to me in par-
ticular—because hadn't it always been her work to make men
happy with food?—as if there were no more pleasurable or im-
portant task in all the world.

I felt, truly, that there was one Grandmother, whom God had

made at the beginning of time, and that it was the strange lot of various old women to become Her: having relinquished all conflicts and expectations, she was forgetful, generous, loving, attentive, devoted solely to food, kindness, and the Word. She did not seem to notice that her daughter had married an exceedingly young man, or that I had hair down to my waist, rubber-banded in a ponytail the like of which had not been seen on any man in Boyce; she had no comment on our at best eccentric and at worst deeply misguided marriage; she seemed neither to entertain nor to consider anything of our circumstance; she was beyond all that now. She did nothing but love us, and dwell in the world of collapse and delight.

My wife, Ruth, didn't hesitate to let me know that she had suffered at Bertha's hands; she had struggled mightily with her mother's sense of convention and propriety (*Come out of the sun, ladies are white, field hands are brown. If you are going to sit in the porch swing in those shorts you will need this throw across your lap*). Bertha had been narrow, she felt, had been afflicted with a poverty of imagination. But none of that was visible to me, for time and chemotherapy had propelled her beyond any expectation of shaping others to her will. She was beyond any struggle save the walk to her single bed, set up on the back porch, since it had been years since she could climb the stairs. For her the world was a plain wonder, and will the very least of it; it seemed a marvel to her that she managed to set her wig upon her head in the morning, and make a pot of strong chicoried coffee in her white enamel French-drip pot, and sit over it and leftover biscuits listening to the pecans rain down on the roof when the wind blew. She stirred her coffee with a silver spoon; poor as she was, she'd kept her sterling, and though Ruth would rail at her mother's ideas of propriety, she would herself scrape together the money to buy a spoon or a silver fork once a month, even when it was

all we could do to pay the rent. I thought they were odd, lovely things, her pickle forks and pearl-handled fish knives, though it was hard for me to see why we needed them.

Out in Bertha's backyard, Chris, the old black man who had done odd jobs for her for decades, was burning the leaves, mumbling to himself, taking little nips from a flask, finding stray bits of twig to toss into the small fire he'd built by the alley, a wide green swath far more bucolic than anything I'd ever known by that name. In a while I offered to drive him home; he sat in the backseat of the car, since it would be unthinkable for us to ride in the front seat together, and I drove him across Highway 1, which divided the town into shadow and light, poverty and what passed for privilege. On the front porch of the unpainted wooden shotgun house, his ancient wife sat reading her Bible aloud, *Praise the Lord* after every passage, and as Chris lead me inside, she said, *Chris, don't you go gettin' in that liquor in there,* and though he said, *Why no, Esther, I won't do that,* he led me right to the big Victorian armoire that concealed his treasure: beautiful glass jars of his own plum brandy, whole fruit preserved in pickled sleep, and poured each of us a shot of the most delicious brandy I've ever known, before or since, dusky, fiery, perfect.

Back home, I'm helping Bertha back to her bed in the little room off the porch—so much excitement and activity, she's weary now. She says, *Oh, I'm ready for a rest.* Then, *Oh, I AM ready for my rest, I'm not afraid at all. I was lying here,* she says, *looking up at this ceiling*—and her rheumy blue eyes turn up to the narrow beaded cedar boards overhead—*and the ceiling went away, and I saw the sky, the blue heaven and all its clouds, and then it all began to swirl and open, just like a morning glory. And there was Jesus in the middle, speaking to me, and he said, Bertha, come in. And since then I am not afraid, not one bit.*

That grand and ramshackle house—a fireplace in every room, a breezeway down the center, the empty second floor haunted and still, where my wife, as a girl, had written beside a hole in the floor meant to collect dust, a chalked inscription you could still read: *This hole leads to the devil's heart*—is long since sold, perhaps demolished, and nothing that was in it remains now, save perhaps some things gone to my wife's brother or his children, who knows. Our marriage ended twenty years ago. And yet how strangely vivid a few things remain: the chipped white French coffeepot on Bertha's table, her beautiful mottled hand holding mine while she lay back on her single iron bed that afternoon, the little pile of twigs and leaves smoldering in the yard. An elaborate spoon embossed with an antlered stag, and a quiver of arrows, emblems of the huntress Diana. The heart is a repository of vanished things: the rock of Gethsemane, jars of plum brandy, whole fruit turning in their sleep like infants in the womb, a heavenly blue morning glory. When I was a kid I had a toy, a "Magic 8 Ball." It was a hard black plastic sphere bigger than a baseball, with a little window at the bottom. The idea was to ask a question, then turn the ball upside down; a message would float into view, suspended in the black liquid which a little jar inside the ball contained (it was difficult to figure this out). "Yes" the ball would answer, or "Perhaps" or "Ask again later." Now I think there is a space in me that is like the dark inside that hollow sphere, and things float up into view, images that are vessels of meaning, the flotsam and detail of any particular moment. Vanished things.

Or vanished from my life, at least. Who knows where they might be now, to what use they may have been put, what other meanings have been assigned to them?

A poem of Cavafy's, "The Afternoon Sun," describes re-
turning to an upstairs room after many years, a room that was
the site of a passionate affair. Actually, Cavafy never says the
room is on a second or third floor, but I cannot imagine it other-
wise; how could such longing and regret take place right on the
street? The poem is suffused with the poet's characteristic mood,
a mixture of ardor and ashes, regret and affection. "This room,"
he writes,

> *how well I know it.*
> *Now they're renting it, and the one next to it,*
> *as offices. The whole house has become*
> *an office building for agents, businessmen, companies.*
>
> *This room, how familiar it is.*
>
> *Here, near the door, was the couch,*
> *a Turkish carpet in front of it.*
> *Close by, the shelf with two yellow vases.*
> *On the right—no, opposite—a wardrobe with a mirror.*
> *In the middle the table where he wrote*
> *and the three big wicker chairs.*
> *Beside the window the bed*
> *where we made love so many times.*
>
> *They must still be around somewhere, those old things.*

From the first line of the poem, we begin to participate in a pro-
cess of recollection—re-*member*-ing, giving the room back its
body. First we see what's become of the room now, and then the
second stanza, that near repetition, seems to center us in, bring-
ing us more deeply into memory tinged with feeling.

Then Cavafy begins to recreate for us the contents of that room. They all come flooding back, "those old things." Couch, chairs, mirror, and bed literally held that man; yellow vases and table and mirror made context for him, defined the space in which he will be recalled.

That next stanza, a lonely sentence floating in space by itself, is a kind of verbal sigh: *They must still be around somewhere, those old things*. In a way this is an act of deflection—the memory of lovemaking is so sharp that the speaker must turn away from it to the objects the room used to hold. But there is something astonishingly poignant about it, too: poised, full of acceptance, the adult recognition that the things of the world go on without us, that the meaning with which we invest them may not persist, may be visible to no one else, that even that which seems to us most profoundly saturated in passion and feeling may be swept away. Our speaker tries for this kind of wistful acceptance, but he cannot stay there; he returns to his imaginative recreation of the room:

> *Beside the window the bed;*
> *the afternoon sun used to touch half of it.*

> *. . . One afternoon at four o'clock we separated*
> *for a week only . . . And then—*
> *that week became forever.*

How many afternoons must he have known the path of the afternoon sun, watched and felt the motion of that light warming his own skin, and the skin of a lover? Was it afternoon because that was when they could meet, only free then? Were they hiding? Was the light striped through blinds or shutters, filtered through a curtain? A bed half in light, half in darkness seems

somehow to introduce the terrible passage of the ellipses, three
little dots of silence that here are dense with meaning. What
happened, in that silence, between the touch of the sun and one
particular four-o'clock meeting? Something to do with the rea-
son they only met in the afternoons? It hardly matters now; once
experience has become part of the past, can it matter how it got
there, irretrievable yet persistent? Ellipsis and dash provide all of
narrative we're allowed, before the final pronouncement.

For years I didn't much like the end of this poem; it seemed
to shut things down with terrible finality, to focus on the end
of the relationship in a way that struck me as blunt and merely
hopeless. But now I hear some subtle note of redemption. The
poem may end with loss, but its title points toward what is
retained, held in the mind: that particular tactile memory of
light-warmed sheets and skin. That afternoon sun—now that is
forever, too, isn't it?

In still life, it's the same: these things had a history, a set of per-
sonal meanings; they were someone's. The paintings seem to re-
fer to this life of ownership, and to suggest something of the
feeling attached to things, while withholding any narrative.
What could we ever know of this cup or platter, the pearl-
handled knife? Their associations are long since dead, though
something of the personal seems to glow here still, all its partic-
ulars distilled into an aura of intimacy.

And something of that clings not just to the representation of
things, but to objects themselves, doesn't it? I have an old sil-
verplate pitcher, a sturdy and serviceable thing made for use in
a hotel, or a boardinghouse, or on a train. Simple, shapely. It sits
now in the center of a painted blue round table, beside a white
tureen holding a small shell-pink begonia from the A&P, the

flowers clenched, a little reluctant to open indoors, in March, in New England. It has been a long time since the pitcher has been in service, exactly; now it radiates a sort of dignity, acquires from the company of other things a different sort of status of being. It holds the image of the room—small rectangular frames of windows, walls bending inward—upside down in the irregular sheen of its various metals. Where the body of the vessel bells out, at its midriff, the silver's worn away, revealing the brass beneath; it's here it must have been rubbed the most, as it was washed, year after year. Along the base there are dents and indentations, abrasions where it's been set down, hard, or pushed across a counter, or jostled in a sink. These marks and wearings-down mark the evidence of time, the acclimation of the object's body to human bodies. They are what make it beautiful; it may have been handsome, to begin with, but I believe that its beauty is the result of use, of being subject to time.

There is a whole community built around the reassignment and redistribution of things. It pretends to be concerned with value, and of course on one level it is; there are precious objects that escalate in price, and represent concrete forms of wealth. But many things next-to-worthless, or only of ordinary value, like my scarred pitcher, are also there to be dealt with. Things must go somewhere when they are relinquished; orphaned belongings must be placed, settled, in order to keep the world aright.

When my partner, Wally, and I moved to Vermont, we bought a thirteen-room Italianate Victorian house, built in Montpelier in 1884. Let me hurry to say, lest this summon visions of grandeur, that this was never a grand house—it was built, most likely, as housing for granite workers, at the foot of a granite hill where the homes of the better-off rose in the winter sunlight.

We were down in the hollow at the butt-end of the hill, pitched into winter shade, and in January saw little of the sun. And the house in fact seemed to have been heading downhill since it was built; the floors sloped with fun-house abandon, and the floorplan had been mysteriously altered until it also bore a certain resemblance to a carnival maze. The outside was clad in mustard-yellow clapboards with brown trim, and the whole place was ringed by a particularly sorry-looking brown picket fence, half its points snapped away by neighbor kids.

But we were eager, and full of visions of possibility, and if the house was a daunting prospect, it was a palace nonetheless. We had been together for only a couple of years, living in and around Boston; I'd been a temporary typist and a part-time teacher, Wally a designer of window displays for a failing department store, and the idea of actually having our own house seemed astonishing. But I was offered a teaching job in Vermont, and I had a grant from the Massachusetts Artists Foundation, and here was a house we could actually afford. Driving by on the way to show us something else, the realtor had said, *Oh, you don't want to look at that, that needs to be torn down.* But it was $24,000, and we had just enough cash for the down payment. Even then, we had a hard time convincing a bank to give us a mortgage that small.

But there was nothing small about the interior of that house, room after slopey room, and it sent us out into the world of yard sales and sale barns and flea markets, and that is how we found our way to the realm of auctions, a time-honored system for the redistribution of the possessions of the dead.

I loved best the ones that took place at people's houses, for then the narrative of a life was most available; then those cases of canning jars and boxes of ancient magazines, those collections of screws and old latches, mixing bowls and tin cookie-

cutters, horse tackle and amateur paintings of birds made a kind of sense. It was like a kind of excavation, seeing things carried out, up from cellars, out of attics and back rooms, out onto a lawn where people gathered under a tent, or on folding chairs, warming themselves with bad coffee and cheap hot dogs bought on the spot. The auctioneer droned on and on, telling jokes to spike our interest whenever attention flagged, attempting to mix desirable items in with long runs of the irredeemably dull. Often there would be one thing we wanted, and if we wanted it badly enough we would wait and wait, as he slogged through numbered lots toward the one that intrigued us. I learned to bring schoolwork with me; I'd read my students' poems and essays while the gavel fell and another armoire or lawnmower or carnival glass punchbowl was carried to the block. We befriended one auctioneer and his wife, whose sales we used to go to regularly; she'd sign us up for a bidding number and always want to talk a while, taking us both in with her eyes and nodding in a way that somehow acknowleged our status as a couple without it ever being specifically named. She held some special affection for us that was somehow conveyed in the way she'd greet us and take time to talk; she handed us our rectangular bidding number as if it were a gift. And every once in a while, when we'd venture a small opening bid on some little thing, her husband would cry "Sold!" and it would be ours before anyone else had a chance—an auctioneer's way of rewarding a regular customer.

There are specific things I remember buying, beloved things. A green stepback cupboard, with upper doors of rippled glass, and beautiful grooves where the turning of the latch had worn the milky apple-green paint away. A wooden panel painted (badly, but delightfully) with seven different wild birds, shown

in impossible proximity: eagle and hawk and owl side by side on a branch. A huge oak table—which I no longer own, and its loss pains me—from an old hotel in Barre, all its drawers autographed and dated by bellhops and waiters and kitchen staff. A big mercury glass ball, of no discernible use. An astonishing yellow chest of drawers, painted with an urn of weepy-looking lilies. A simple, cream-colored chair, with a seat of woven wooden splats, on whose ladder rungs someone painted, quite delicately, three perfect red cherries. An unfinished violin, of bird's-eye maple, in two parts—the top carved out as a single piece, complete, and the violin-shaped block of uncarved wood that would have been the fiddle's bottom half, the two parts together purchased for a dollar, and feeling, in the hand, like music emerging out of silence, or sculpture coming out of stone. A perpetual wooden emblem: something forever coming into being.

These things are informed for me, permanently, by the narrative of the auction, an experience of participation. The auctioneer and his runners—an odd assortment of small-town Vermonters, from teenagers to old men, all in their heavy workclothes, their flannels and boiled wools—made up one cast of characters, repeated from sale to sale, with variations in the crew. We buyers or potential buyers comprised the other, an odd mix of gnarly dealers and stylish couples furnishing old houses, well-heeled buyers from elsewhere, women in handknit sweaters with sheep on them, a sprinkling of gay men. We were of a tribe who understood ourselves as curators of objects, some of which would outlast us. We eyed all that was offered, imagining where it had come from, talking to other bidders or competing with them or both. Sometimes deals were made on the spot; you could own something for a few minutes and sell it again to an

eager collector, or refuse to. This one wanted only junk; this one had so much money that it was useless to bid against her; these two liked precisely what we liked. Wally had wickedly comic names for them, all of which have vanished from my memory in the years I haven't seen these people we hardly knew anyway.

There was an odd feeling of adventure about it—one might be caught up in the fever of the moment and buy something entirely unanticipated; one might take some strange risk. My heart always used to start pounding, at the moment of bidding, a little adrenaline rush, as if what was taking place were deeply risky and consequential. Well, we were poor—that was certain, so there was an element of risk, but we never spent *that* much. Instead, it was about being part of a drama, an enactment of community that went on around this box of plates, this trunk of Masonic temple costumes, this ruby glass compote. And a feeling of magic, too—no matter how early we came or how carefully we looked, the auctioneer would always hold up something we'd never seen, offer something we hadn't noticed before, as if he pulled things up out of a bottomless well.

Indeed, these things could go on and on. I used to love the moment, late in auctions, when stuff began to be crammed together into "box lots." By then the crowd would be thinning, the best things gone; only the diehards remained and the auctioneer and his carriers were running out of steam. So they began to toss things together, producing boxes from who knows where and crying, Do I hear a dollar? How many times we fell for this temptation I couldn't say; we seemed to always have boxes to sort out once we got home. They'd yield perhaps one lovely old pressed wineglass, or a single volume of some beautiful leather-bound nineteenth-century encyclopedia, or one handsome photograph. And endless Tupperware, chamber

pots, rusty kitchen utensils, old tins of paint, and jam jars full
of nails and screws. It wasn't long before we'd filled the rooms of
the house we actually used, tableaux and still lifes of old things
spilling over, one season's purchases crowding out the last's.
Then we turned an unused upstairs room into a storeroom, and
soon it was piled to the ceiling, with pathways weaving in be-
tween the towers of things.

The first Dutch still lifes are texts of abundance; the painters
themselves seem startled by the bounty of the harvest, the lar-
der's profusion of meat and fish and fowl. They are celebrants of
prosperity, and observers of the consequences of relative stabil-
ity; they are a little intoxicated by the new successes of agricul-
ture, and the economic power of a culture committed not to the
absolute wealth of the few but the broad prosperity of the many.
Sometimes in the background of these pictures something im-
portant happens—Jesus visits the house of Mary and Martha,
for instance—but only in one small corner of the canvas, while
the rest is overwhelmed by cabbages and pheasants, cucumbers
and snap peas, scallions and cauliflower, hams and hares and
jugs of who knows what.

But in only a matter of years, something happens: these
paintings of indulgence give way to something more rigorous,
certainly more poetic—compositions in which the terms are re-
duced, and their import seems to lie not in plenty but in the po-
etry of relation: here is the sharpness and translucency of lemon
beside the differently fragrant and more solid body of fish; here
is light on a white damask cloth, a knife, a loaf of bread. Here
are harmonies and gradations of texture, of scent, of flavor, of
light; look at these degrees of reflectivity, the way each of these
elements responds to light's lavish attentions. "Lavish" is the

word, though the bounty of the earlier paintings is gone; this is the realm of the ordinary sublime: the extraordinary, daily behavior of light. The important event in the distance has vanished; the important event is here, now. Daily blessing. Plain abundance. There is almost no background in these paintings at all, simply a lustrous dark space, in black or deep leathery shades or pearled expanses of gray; it is a warm neutrality that brings things in the foreground to startling life.

Of course there would continue to be still lifes which are testaments of wealth—the paintings of Willem Kalf, for instance, with their astonishingly grand vessels made from nautilus shells set in silver, their platters of chased gold. These praise the accomplishment of artisans, and the grand profits and storehouses Dutch commerce assembled from domination of the seafaring trade. Of these paintings Goethe commented that he would rather possess the painting of the thing than the sumptuous object itself; the image, as rendered in oil, was more lovely and, finally, more desirable. I agree, but it is the image of the daily world I'd prefer to own. When both are made of paint, is a cabbage any less precious than a golden cup?

I used to get up early in the seaside town where Wally and I lived the last years of his life, and walk our dog, Arden, a black retriever with a luxurious coat of curls, along the harborfront and into town. We'd go to the Lobster Pot, a big tourist restaurant that featured, among tanks of crustaceans, their claws sadly taped together but still waving a little as they brooded beside bubbling pumps, the unlikely addition of a bakery counter. I'd buy a muffin—baked by my friend Peter, who must have been draining away the profits of the restaurant by filling his pastries with pecans and raisins and slices of fruit—and a large cup of

coffee, and Arden and I would go and sit behind the hardware
store, where we could sit on an upside-down dory and eat—a
bite for me, a bite for the not-quite-slim dog—while we sur-
veyed a kingdom of beached and ruined boats, and beyond
them the expanse of bay in that day's metallic shade—some-
times silver, sometimes pewter, sometimes a wintery gunmetal,
or a startling fresh anodized blue, a blue with a bite to it.

Some days I'd find shards of china on those shore walks, as if
I'd been offered a bit of that blue to keep. The bay is forever spit-
ting up broken bits of dishes, evidence of a nineteenth-century
dump out among the waves. Any morning I found a blue and
white piece seemed to launch a lucky day, as if I'd been granted
some token of happiness.

Some days we would walk farther into town, out of a desire
for variety. One April morning we encountered a yard sale in
front of Spiritus, a sure sign of spring, both the sale itself, since
cleaning out and the desire to divest oneself of excess come with
the season, and since the restaurant itself was open. Spiritus is
only a pizza parlor with an elevated name, but it holds in my
town a certain centrality that partakes of myth; when it opens,
the sleep of winter seems shaken off, and the season is said to
begin. Its position as a gathering place has nothing to do with
the coffee or ice cream—nor most certainly the pizza—it serves.
Rather it's about the courtyard on the street, the benches, the
low brick rise along the sidewalk where one can sit. It's our com-
munal gathering place, decked every summer night with towns-
people and visitors displaying and satisfying hungers of every
sort.

On this particular morning, somebody who worked there
had spread out a hodgepodge of stuff, utensils and lamps and
blankets, books and dishes. I was being cautious about such

things, because Wally and I had divested ourselves when we moved. We no longer had whole rooms to use for storage, or endless walls for hanging more dusty landscapes, and we'd sold more than we'd brought with us. We'd rented a U-haul and driven to a flea market, at dawn, with all we'd decided not to bring along; even as we were unloading the truck, the dealers lurched across the grass toward us, in the half-dark, like the ghouls in *Night of the Living Dead.*

So I was resisting accumulation. But there in the center of the sale table was a large blue and white china platter, picturing in its center a resting group of antlered deer. I reached out to lift it up, and asked the bearded and sleepy salesman the price—five bucks! I kept it tucked under my arm, since I knew if I set it down the next shopper would immediately snatch it up, and reached into my back pocket for the cash. I didn't see whatever else was spread on the bench or the makeshift folding table whose legs Arden was busily sniffing; my attention was taken, entirely, by the big oval field of blue and white. It didn't matter that it had, long ago, been whacked against a table or knocked by a glass, so that a triangular piece the size of a canape had been broken from the rim, and then replaced with some plastery mending compound, a little rough around the seam, or that a dark crack or two zagged inward from the edge. It was five dollars, after all, and there were those dreamy, cobalt deer.

Blue and white china holds a deep pull for me, because my mother loved it, and my parents' house was full of old pieces she'd found. There were none from her childhood—whatever had happened to those old family dishes, they hadn't come to her—so she scavenged yard sales and what was called in Tucson the "swap meet," a big open-air flea market held, weekend mornings before it got too hot, on the broken asphalt of a drive-

in movie theater. She liked to buy patterns she remembered
from her childhood—old "flow blue" transferware, whose inky
images had blurred and spread, and the famous Blue Willow
with its narrative of lovers and bridges and birds, and a scrolly
pattern featuring a Russian-looking two-headed phoenix called
Firebird she said used to be given away at the movies when she
was young, a different piece every week free when you bought
your ticket. They lined her mantel shelves, and then the kitchen
cabinets, and then our burnt adobe walls. She didn't care if the
pieces she found were chipped or cracked; she liked, in fact, get-
ting a bargain, and had no real interest in the china's value or
use; it was about touching back to something lost to her, some-
thing embodied in the crisp or wavering but always serene blue
patterns on their white ground.

So with my platter under my arm, walking home, I feel
linked to something of my mother's childhood and my own;
something of promise in it, something of collective memory.
And clearly it's not just my memory or my desire; the streets are
filling up now, the morning shoppers and strollers stirring, and
because it's Saturday the yard-salers are out in force, and I am
aware of a great many pairs of covetous eyes—particularly the
eyes of gay men!—on my new purchase.

Which Wally loves, too, when he sees it, inveterate collector
that he is, and soon we have the perfect place for it. A man who
designed display windows for a living, until he grew too sick to
work, he had a respect for beautiful things, especially simple,
clean-lined objects that displayed evidence of use and time. He
made any space we lived in, no matter how shabby, beautiful—
a few yards of fabric, arrange things just so, adjust the lighting,
there! Time to call *House Beautiful*. In the living room, we'd
constructed a mantel out of old wood salvaged from a guest-

house under renovation (the Shipwreck Inn, it was called, every room named for a different disaster—imagine sleeping in the *Lusitania,* or the *Edmund Fitzgerald*). Above its soft celadon-darkened-toward-putty-green is a strip of rough plaster perhaps two feet wide, subtly darkened with fireplace smoke. There, right in the center of that once-white, the platter seems to come to rest naturally, bordered by exactly the right amount of open space, at ease in its framing field.

There is a Japanese word for things made more beautiful by use, that bear the evidence of their own making, or the individuating marks of time's passage: a kind of beauty not immune to time but embedded in it. This aspect of the platter seems honored in its new place, an essential component of what it is, and therefore an aspect of its loveliness. It makes the platter "worthless," and somehow this seems better, too; since its beauty is not conventional, does not translate to monetary worth, it's a little subtler, a little less easy to see. This damage makes our platter unique, in all the world; probably there are other whole ones, unblemished, but there is nothing anywhere just like this.

The most beautiful still lifes are never pristine, and herein lies one of their secrets. The lemon has been half-peeled, the wine tasted, the bread broken; the oysters have been shucked, part of this great wheel of cheese cut away; the sealed chamber of the pie, held aloft on its raised silver stand, has been opened. Someone has left this knife resting on the edge of the plate, its handle jutting toward us; someone plans, in a moment, to pick it up again. These objects are in use, in dialogue, a part of, implicated. They refuse perfection, or rather they assert that this *is* perfection, this state of being consumed, used up, enjoyed, existing in time.

But there's the paradox—they are depicted in a moment of being seen, contemplated between the experience of tasting, smelling, devouring; but this depiction places them outside of time, or almost outside of it, in a long, slow process of decay, which is the process of oxidation, of slow chemical transformation, like the paint in Nellius's medlar going cloudy under the influence of extruding crystals of arsenic. Whatever time may have done to the original fruits, their depiction is now safe from the quick corrosions of local time and subject to the larger, slower depredations of history.

And thus something of the imperfect, the quickly passing, the morning meal with its immediate pleasures has been imported into the realm of perfection, into the long, impersonal light of centuries.

I tried to move the blue and white platter, later, as the room changed, as things came and went. We both loved rough old paintings—clumsy landscapes, sweetly sentimental renderings of rivers and mountains—and I was forever trying one in that spot, but only the platter felt right. If I took it down, in a day it would be back again. In a while our living room became a bedroom, since Wally could no longer walk up stairs. Then, our big four-poster had to go, since he needed a hospital bed we could crank up and down. I put a single iron bed next to it so we could sleep side by side, and did what I could to keep the room looking like home, but increasingly the sickroom stuff intruded, pushing other things away. But not the platter; those tranquil blue deer remained as witnesses, focal point, silent gesture.

Later the room changed again—became my bedroom only, after Wally's death, the hospital bed dismantled and trucked away by the rental company, the room strangely resonant, vi-

brant. A writer I know despises that word, insisting it's so mean-
ingless that it should never be employed. But how else could I
name the odd, profound sense of life in that room, life lived out
and through? The house has a decided feeling of idiosyncracy,
of soul; not in the wide-pine planks of the floorboards exactly,
not in the rough-hewn hemlock ceiling beams, though those are
part of the matrix of the place, aspects of its embrace. Old
houses gather that sense, and this one has been accumulating its
store of lived experience for two hundred years. Wally wasn't the
first to die there, but I felt his death filled the space with a
strange, vital light—a light inside the light—so that it became
(I can say it no other way) vibrant.

And the room changed again. The sense of heightened expe-
rience subsided; I felt as if the door between myself and the
other world, which had remained a little ajar, so that I could see
some distance beyond the daily, closed. My life lurched and
halted and moved forward again. I slept downstairs for a year,
and when Paul and I began to see each other, he helped me move
the bedroom back upstairs. My platter, both broken and whole,
has been hanging in its single spot for nearly ten years now. Be-
cause I've moved a great deal, ever since I was a boy and my fa-
ther was a constantly mobile Army Engineer, ten years in a place
is a very long time to me; it is permanence, stability, rootedness.
It is what I want most in the world, although I'm always fleeing
it, too, always traveling to work or to speak or to teach. Paul and
I leave Provincetown for half of each year, since there's no way
to earn a living here, and since we need a wider world than our
little town offers anyway, at least for part of the year. So in win-
ter the house is closed, the pipes drained, the furnace shut
down, and nothing stirs but the few inevitable mice come in for
shelter from the New England cold. I like to think of the place

turned in on itself, awaiting our return; I anticipate that reunion, while we are away, and one of the things I imagine in the darkened house is the blue and white platter, catching in its glazed rim a little red from the late afternoon sun firing in through the bare rose vines around the windows, or, later, light from a streetlamp outside. I am learning to accept the flux and revision time and experience invariably make, but I am also learning to love what I wish to keep the same, something that nothing in my life has taught me until now; learning, that is, not to let go but to hold on. I hold on to the mended, exactly right old platter, fixed in its place, cherished, singular, at rest. If it is a reminder of loss—my mother, my lover vanished in the slipstream of time—then it is equally a token of what can be kept: a sense of home, of permanence, of the ground for ourselves we can make. "Our houses," wrote Mary Heaton Vorse in a memoir of Provincetown called *Time and the Town*, "are our biographies, the stories of our defeats and victories." Her house still stands, a bit ramshackle, alive with character, near the harbor, a few blocks from here. An old hymn word comes to mind: abide. Her house and mine abide.

Bowl of blue and white porcelain, pewter plate, glass of wine: ordinary things. The still life's movement toward simplicity comes to its oddest—perhaps inevitable—conclusion in the development of paintings of single things, rendered with an absolute attention, a perfection of eye and hand brought to what is no longer in dialogue with anything else, but a simple one-on-one exchange, object to viewer. In 1697, for instance, when Adriaen Coorte was in his early thirties, he painted *Still Life with Asparagus*. The title misleads; there is nothing to be seen *but* asparagus, and never has it been so thoroughly seen. A bundle

of stalks, tied by a bit of raffia or twine, rests on the edge of a stone slab or ledge, propped at a slight angle on the back of a single stalk that has perhaps slipped out of the pack. The stalks have been blanched—grown, that is, in shallow trenches of sand, by which the body of the stalk is gradually covered, as it sprouts, so that the flesh will remain white. Though that term is far too simple for the actual color of these stalks: a pale lemony shade, tinged with a little green, shadowed on the underside, particularly where the curve of the bundle falls away, in its lower reaches, into darkness. The shade of these stalks—exactly right, as a look at a bundle of asparagus grown in this European style today confirms—is achieved through a mixture of ash, lead white, and a color called *schiet geel,* or shit yellow. This was made of buckthorn berries (a laxative, thus lending the hue its name), which produced a warm, golden tone, though one prone to fading. "It fades, it bleaches, it goes away!" lamented one commentator, Theodore Turquet de Mayerne, who in 1620 began to compile a manuscript on the chemistry of painting.

Near the bunched and armored tips the stalks begin to darken; they have been painted precisely as a seventeenth-century technical advisor, Wilhelmus Beurs, proposes. Beurs, of Dordrecht, married a silversmith's daughter in Amsterdam and painted portraits, though apparently a fondness for drink and tavern life ended his urban career. He moved to a small town, became a floral painter and teacher, and turned his attention toward the composition of a manual for painters. Here is his advice on asparagus: "The asparagus are also easy to paint: however, it has to be noticed, that the buds on top of the purple ones should be painted with black, lake and white, or with lake, indigo, black and white; that which has been under the earth is similar to celery and endive. . . . "

In Proust there is a similar moment, when the close examination of a bundle of asparagus stalks in Françoise's kitchen reveals a color range not unlike the one Beurs prescribed. "What most enraptured me," the narrator says, "were the asparagus, tinged with ultramarine and pink which shaded off from their heads, finely stippled in mauve and azure, through a series of imperceptible gradations to their white feet. . . . "

Purple, black, indigo, ultramarine—not the colors convention would associate with this vegetable, and yet in Coorte's astonishing painting one sees the fierce veracity of the results: here, in all its pronged, nuanced glory, a bundle of stalks resides in the full, fleshy resonance of its three-hundred-year-old presence. They look edible, earth-scented, alive; no matter that the lead white has reacted over time with something in the oil medium in which it is suspended, lending the stalks such a pronounced transparency that you can see, right through the stalks, the edge of the stone surface which supports them. That ghostliness only adds to their charm.

All of which simply begs the question . . . *why.*

There is no drama here, no subject in which we might be expected to locate meaning, much less transcendence; there is no poetry of relation, and no value ascribed by rarity or worth. We have, instead, simply a bundle of well-grown asparagus, which seem to have been freshly cut, and placed against a field of darkness so that we might see them, just so, so that we might attend with something like—though who could hope to achieve it?—the fixity and intensity of attention that Adriaen Coorte has brought to his work.

Of course the purpose of such a gaze has been considered, guessed at, theorized. Erasmus thought such painting made us "twice pleased, when we see a painted flower comparing with a

living one. In one we admire the artifice of nature, in the other the genius of the painter, in each the goodness of God." Wouter Kloek, in an essay on still life, writes that the painters "would reproduce the model . . . imitating every texture and every surface to the best of their ability. There was no call to do this except for customers eagerly anticipating the realistic representation of a candlestick in the flat plane, or olives so lifelike that you could almost pick them off the plate, or a bird's feather floating on the water, propelled by the wind."

But if the painters were driven by an eager marketplace, to what do we attribute the interest of the consumers? Surely their excitement was not merely technical; the wonder generated by skill in the reproduction of appearances is a limited phenomenon. For a hundred years, a remarkable number of painters flourished in the Netherlands, a large portion of them masters of some peculiarly specific kingdom of still life, specialists in the representation of sweets, or silver vessels, or cheese, or wine in glasses. We are not talking here about a master or two, but an oddly egoless outpouring—selfless in retrospect, at least, when it seems that a nation and a century gave itself over to a deep romance with the painted image. Zbigniew Herbert suggests that such paintings "increase the store of reality"—they offer us more images, more world.

More world, just when you think you've seen what there is to see. That is how I felt, coming back to life after a period of grief, reentering the world. Well, that phrase is somewhat misleading. Of course I'd never left; it was simply that I was going through the motions of a life in which I no longer had faith, because I had come too close to death. I'd seen through to the other side of the daily, and I could not help myself from focusing on the

fact that everything disappears, everything's brief. I'd see lovers in the street then and think to myself, Don't they know? Can't they see where they're headed? I was possessed by *vanitas;* I needed no reminder.

Desire brings us back. My exuberant, golden new dog, racing down the sand slopes of the Beech Forest toward me, sheer embodiment of eagerness, given over entirely to running, wind streaming his long ears back, his eyes filling with me. The roses, in June, which deck the front of this house in a flaring pink crescendo of bloom, old roses, dense flowerheads packed with petals, with handsome and evocative names: Eden, Constance Spry, Madame Grégoire Staechelin. The startling quality of presence in Paul's eyes, when they are suddenly direct, warm blue-brown, catching lamplight. The particular whole-body enthusiasm with which he gives himself over to something he loves, outcries of delight that know no reservations—for Joni Mitchell singing a moody ballad, or the sight of our old retriever, Arden, sitting poised in the falling snow, completely happy, his dense black curls gone arctic.

Not that grief vanishes—far from it—but that it begins in time to coexist with pleasure; sorrow sits right beside the rediscovery of what is to be cherished in experience. Just when you think you're done.

A painting of asparagus, a painting of gooseberries, a painting of five shells arranged on a shelf. Exactitude, yes, but don't these images offer us more than a mirroring report on the world? What is it that such a clear-eyed vision of the particular wishes to convey? A way to live, perhaps; a point of view, a stance toward things.

Let me try to elaborate.

First, a principle of attention, simply that. A faith that if we look and look we will be surprised and we will be rewarded.

Then, a faith in the capacity of the object to carry meaning, to serve as a vessel. For what? Ourselves, of course. I mean that the objects depicted are, ultimately, soulful, are anything but lifeless. Of course they have lost their particular contexts, all the stuff of narrative, the attached human stories that would have placed them in some specific relation to a life, but they are none-theless full of that life, suffused with intimacy. Louise Glück has written that poetry is autobiography stripped of context and commentary; this statement is true of still life as well—how else could these few things on the table before us, arrayed against the dark, glow with such a fierce warmth?

Suppose I were to make a still life of my grandmother's pep-permints, those remembered little tokens drawn from infin-ity's dark sack and offered, again and again, to me, and once, vain gesture, offered to those dark presences who came from the darker spaces between the trees, coming to see what we'd brought them? Little gesture of wildness or defiance, little en-compassing moment, a funny sort of grace. Flannery O'Con-nor's old woman held her hand out to the Misfit who threatened to kill her and said, *Why, you could have been one of my own chil-dren.* Is that what my Mamaw was saying to the bears, as she offered them candy?

I could array those little disks in their transparent wrappers against the dark, place them on a stone ledge as Adriaen Coorte would. His gooseberries remind me of my grandmother's pep-permints; startlingly veined little globes poised on another of those stone ledges, they glow coral and acid green against the dark. They are heartbreaking. I would want my candies like this, perhaps lying alone on a surface, perhaps a group of them

in a silver dish. There was such a dish my mother loved, years ago, a circle of chased and hammered silver a missionary aunt had brought home from Korea; a dragon circled the rim, head coming to rest amid the coils of its own tail. It was a calling-card dish, my mother said, intended to hold the tokens of whoever had come to visit, relic of leisure and gentility. She held it up as an object to be regarded, memento of lost days and better ones. She bought silver polish especially for it, and made the little dish gleam.

Where is that silver dish with its incised dragon afloat on clouds of smoke? Where is the old oak bureau that held my grandmother's folded supply of rubbery stockings? They must still be around somewhere, those old things.

These associations—Cavafy, my mother polishing the silver, a missionary aunt who fled the familiar turf of Tennessee for the otherness of Korea (presumably with the intent of teaching them something, hopefully with the result of being taught), my Mamaw's fragrant old bureau with its smell of wax and polish— all of them would be brought to bear upon my painting of peppermints, but none of them would be visible; there's no reason the viewer would know any of this. I could render only what can be seen—color and form, though the painter's splendid artifice reveals to us texture, too, and rich associations of scent and flavor, all arriving through the gates of the eyes.

And yet there is something more here, and that something is what nags at me to write this book, what tugs at my sleeve and my sleep. Why, if all that is personal has fallen away, should these pictures matter so? Why should they be alight with a feeling of intimacy? Interiority makes itself visible. In my imaginary still life, the "context and commentary" of my experience would be gone, but something would remain, something dis-

tilled and vibrant in the quality of attention itself. Is that what soul or spirit is, then, the outward-flying attention, the gaze that binds us to the world?

Coorte's asparagus, his gooseberries and shells, distill this quality down to its quietest, most startling essence: the eye suffuses what it sees with I. Not "I" in the sense of my story, the particulars of my life, the way my father tended his old asparagus beds each spring, the way my beloved loved the forms and colors of shells. But "I" as the quickest, subtlest thing we are: a moment of attention, an intimate engagement.

Is that the lesson, then, that ultimately I becomes an eye? What is left of Adriaen Coorte but this? Isn't that enough?

Certainly this is true of poetry, the poems of the dead. Where there was a person, a voice, a range and welter of experience compressed into lines and images, now there are only lines and images. Where there was a life, now there is a form.

And the form, spoken, breathes something of that life out into the world again. It restores a human presence; hidden in the lines, if they are good lines, is the writer's breath, are the turns of thought and of phrase, the habits of saying, which make those words unmistakable. And so the result is a permanent intimacy; we are brought into relation with the perceptual character, the speaking voice, of someone we probably never knew, someone no one can know now, except in this way.

A still life is more like a poem than it is like a portrait. When you look at a representation of a human figure—a shepherd, a saint, a prince—that figure looks back at you; the painting is concerned with the experience of animation, with what will give soul to the figure before us. The end of our seeing is in the eyes of the figure that seems to see us, that looks back toward us,

quizzical, alive, caught. It is at the eyes of a portrait, always, that our seeing stops.

But in a still life, there is no end to our looking, which has become allied with the gaze of the painter; we look in and in, to the world of things, in their ambiance of cool or warm light, in and in, as long as we can stand to look, as long as we take pleasure in looking.

Pleasure and pleasure—it is my forty-fifth birthday, and Paul and I are in Amsterdam, where we have never been, and today I am allowing myself whatever brings pleasure. Breakfast, first, early, in the narrow kitchen of the narrow hotel where we are staying, a seventeenth-century canal house, startlingly tiny, centered around a winding wooden stair that requires vigilant attention, upon any ascent or descent, to avoid trouble. Outside the kitchen window a great blue heron perches atop a boat tethered at canalside, a spike of feathers on his head contributing to a particularly urban, grizzled look; he's waiting for the neighbors to throw out food, his assessing, practiced eye both jaundiced and bright. This is one gritty, experienced bird.

And then we're off to the Rijksmuseum, where there is, unlikely fortuity, an exhibit called Still Life Paintings from the Netherlands, 1550–1720, as lucky a birthday gift as I can imagine. Though it's early, we still must wait in line outside, in the gray morning, in a paved courtyard where tour buses idle and disgorge their obedient troupes: Americans, Germans, Japanese, all ushered together before the towering gray eminence of the museum, from whose ramparts hang banners advertising the show. These depict a single, lavish parrot tulip, against a black field emblazoned with a single red word: *Stilleven*.

I can hardly wait to get to the rooms of still life. We buy our

tickets and check our coats, we pass the tempting galleries with their proffered distractions, we enter the cool gray suite of rooms, a space that seems to me, in memory, hallucinatory, heightened. Beautiful chambers, skylit, room after room of these somber poems of materiality. Here are Osias Beert's resplendent, living oysters, ashimmer on their silvery shells, their pewter plate; here are the elaborate beakers of Willem Kalf; the translucent asparagus spears of Adriaen Coorte, sturdy and good-natured vegetables that suddenly seem to verge upon mystery. Here are cabbage whites, an atlanta, a great bear butterfly, a rhinoceros beetle. "The profusion of minutiae," the catalogue says, "underlines the impossibility of being able to completely chart, let alone comprehend, the still life." Like the world. An undulant caterpillar approaching Ambrosius Bosschaert's knobby glass vase (glints, refractions, shadows) of tulips and lilies and fritillaries. Clara Peeters's sliced, crumbly, nearly fragrant wheels of cheese, the darkly lustrous bridle of Torrentius, Pieter Claesz's glowing platter of sliced herring, Willem Heda's nearly weightless slice of ham. And that is only the beginning. Here are de Heem's heap of ruined books, here are tobacco pipes and pineapples, papayas and parrots, bundled leeks in a corner of a barn, and the ubiquitous lemons. Here is the meticulous trompe l'oeil of Samuel van Hoogstraten and Cornelis Brize: letters, scissors, coins and keys. A Chinese bowl full of walnuts, a pomegranate, a pocketwatch.

Svetlana Alpert says that looking at Dutch painting is less like looking into a window than at a map or a mirror; these surfaces are intended to stay surfaces; they are the rendered aspect of the world, concerned not so much with the illusion of depth that perspective tries to create as with a scrupulous rendering of the optical surface, things as they are loved by the eye. These rooms are witness to such acts of attention; here is testament

to the eye's profound engagement with the splendid look of things.

And it is a refuge from the welter of streets outside, the crowded and various world in which one is never sure where to look, in which one wishes to look everywhere at once. The serene, solid fruit of Floris van Dijck makes me think of García Lorca, of the lines from one of his "Gacelas" that go, in Catherine Brown's translation,

> *Because I want to sleep the sleep of apples*
> *and learn a lament that will cleanse me of earth . . .*

Maybe Lorca has it right—we want things to wash us clean, we crave the plainness of the unmediated, the directness of apples. If we could live with their solidity, with the apple's clear distinction between inner and outer, how the firm shine and protective color of the peel wraps seamlessly around that fragrant, nourishing core, so that it remains unbruised by air, ready to feed . . . Fit to carry the dark central star of the seeds into the world. In this sense, still life is refuge, consolation, place of quiet. The world becomes bearable, apprehensible because so many elements have been subtracted from it.

But what I'm feeling today isn't retreat, isn't a silent respite; rather it's as if the generous attention lavished on all these things is calling me toward engagement. Is forty-five the midpoint, the hinge point of a life? In the past I have gravitated toward transcendence. I've sought weightlessness, unboundedness, continuity, have followed the wish to be outside of time. I have wanted to escape or deny the body; I have loved art that defies limit, that reaches for a scale beyond the human.

But these paintings fill me with the pleasure of being bound to the material, implicated, part of a community of attention-giving. That is what we do with sight, give it out, give it and give

it away, in order to be filled. Elizabeth Bishop's travelers "looked and looked our infant sight away," and that is what I feel Paul and I are doing today, taking in and taking in, joined to a brethren of the lovers of this world. Who go about their seeing—by lens and by canvas, by microscope and camera obscura, by notebook and daybook—as if it were the most crucial work we could choose.

And of course in a while we are so filled that not even a trek down to the museum restaurant, for coffee and apple tart, will restore our ability to see. We try, but we have crammed our eyes to the gills, if such an absurd mixing of metaphor might be admitted. I find there is only one thing I can truly look at, still, which is a little painting by my friend Adriaen Coorte, champion of the singular. It is the size of a large postcard, and it represents five shells, arranged on that familiar stone ledge, against a background of darkness. Each is completely unlike the other, in color and in form. This one is vulval, this one whorled, this tiny whelk is turned away from us, its opening hidden; this snail is the color of cochineal. And in the center, a murex, spiny, balanced on its delicate fishbone protrusions, its dark gate offered to us. This is a poem of difference, of strangeness; here, the painter says, are five things, five from the same category, and look how unalike they are, what dreamy variety the world offers up. And though the lively light that bathes them is cool, particular, discerning, there is still some strange quality of life about it. Maybe it's what I'm feeling about all these pictures, what I'd never expected of them, which is their sexual presence, their physicality, their bodiliness.

Time to go. It's raining out now, but I'm tired of walking and standing anyway and so welcome the excuse for a perfect rainy-day, entirely touristy sort of activity: the glass-roofed canal boat. At the stop right outside the museum we buy tickets, and soon we're stepping onto the rocking yellow craft, taking a bench in

the back, and then we're chugging along through the silvery
gray glide of the canals. My perfect birthday wish, to be floated,
carried, this long boat making wide turns and fitting itself un-
der small bridges, branches and houses leaning above us. We're
sitting close, our jackets a little wet from the rain. Paul's jacket
is shiny and blue-black; his black shoes are gleaming with drop-
lets; his shoulder pushes against mine. A bit of fog on the win-
dows around and above us from our own heat. I am a little
dreamy with the weight of the paintings, with all that's entered
my eyes. They cannot be generalized about without diminish-
ing them, but I can report on their lesson, which is to remind
us of the strangeness and singularity of things, and therefore of
ourselves. Singularity, they wish us to know, resides in the phys-
ical, the particular, the seen; this knowledge can be looked at,
can be held. Here you are, the painters say, a body in the city of
bodies, in concert, in the astonishing republic of things, the
world of light, which is the same gray world sliding past the
boat, lapping and chilly, alive with detail as the boat pushes for-
ward, slipping away. And then out onto the wider canals, the big
public buildings at either side, even, briefly, out onto the wide
harbor of the IJ.

Sometimes I think these paintings seem full of secrets, full of
unvoiced presences. And surely one of their secrets—some-
where close to their essence—lies in a sense of space that is
unique to them. These things exist up close, against a back-
ground of burnished darkness. No wide vistas open behind
them, no far-flung landscapes, no airy vastnesses of heaven.
This is the space of the body, the space of our arms' reach. There
is nothing before us here we could not touch, were these things
not made of paint. The essential quality of them is their near-
ness.

The space of religious painting often seems designed to

dwarf the body; we become tiny, before the great sky opening behind the saints; we seem to leave our bodies to be drawn into the holy empyrean. But these paintings reside in domestic, physical, fleshly space.

And that is why it is so startling—as Norman Bryson has pointed out in a very useful book of essays on still life called *Looking at the Overlooked*—that everything in this up-close, bodily space is delineated with such clarity. We're accustomed to not seeing what is so near to us; we do not need to look at things that are at hand, because they are at hand every day. That is what makes home so safe and so appealing, that we do not *need* to look at it. Novelty recedes, in the face of the daily, and we're free to relax, to drift, to focus inward. But in still life the familiar is limned with an almost hallucinatory clarity, nothing glanced over or elided, nothing subordinate to the impression of the whole.

That is why, I think, having imbibed such a deep draft of these paintings, I turned toward my lover's body, which suddenly seemed to me such a tangible, intrinsically interesting fact: that's what we are, facts, like the painters' fruits and shells, physical presences. Here was a shoulder against which I could lean my shoulder, jacket to jacket, as the canal boat chuffed forward, our commingled breath fogging the glass, on the other side of which ran droplets of rain.

All those painters, all their lives looking at reality with such scrupulous attention, attention pouring out and out, and what does it give us back but ourselves? What is documented, at last, is not the thing itself but the way of seeing—the object infused with the subject. The eye moving over the world like a lover. And so the boundary between self and world is elided, a bit, softened. And that is another secret of these pictures: these tulips and snails, grapes and cheeses *are,* at last, human bodies, if bodies could flower out.

This is what history is: all those centuries of bodies, mov-
ing over these canals, twisting and blooming into life in these
houses, these streets; all that flesh hungering, coming together,
separating, continuing, accumulating, relinquishing, aging and
breaking down. Bodies as tulips bent to the demands of light,
colored into blossom, spent.
 As if the world were a corridor through which the body
moved.

And now we're moving through a darkened hallway, lit by small,
subtle lamps at eye level, mounted on the walls, which are of a
gleaming reddish wood—cherry? These walls, actually, are cab-
inetry, beautifully made, and punctuated by doors: a series of
little chambers. Some are empty; in others are men posed in
shadow, draped in towels, the subtle light molding bodies allur-
ing or less so. It's the warmest place in Amsterdam, this after-
noon of my birthday; cold rain glazes the streets outside, but in
here the warmth of steam and sauna spill out into these cubicles
and maze of hallways. Downstairs there's a little bar, in gilt and
red flocked wallpaper, a swimming pool, a café where Paul and
I can sit, skirted in our towels; how good it is to be here, not only
in the physical warmth but in the sensual heat of these bodies,
lit from without by the dim torchieres, from within by desire.
I'm not, at this moment, especially interested in sex; that isn't
what's drawn me here exactly, though my motivation might be
said to be sexual—it is to be in relation to these beautiful physi-
cal presences, to all this skin, framed here—like works of art!—
by the little doorways. It is a conviviality and warmth—a frater-
nity of sorts—for which the paintings and the rainy ride on the
canals have made me hungry. I have wanted to feel my body in
this stream of bodies, wanted the odd and lovely way this un-
dressing together affirms our materiality. In this displayed flesh
there is something of the shop windows' finery, things shown to

incite longing, approval, desire. Some relief in becoming material, a certain pleasure in being the object of desire, as if that granted one a respite from being its subject? It seems of a piece with all we've seen today: these bodies seem to be flower and fruit, insect and snail, permanent and perishing, ripe and decaying. I don't really want to touch; I want to see the men as I have seen the rowed treasures of the Rijksmuseum: visual emblems of experience, beautiful histories only partially available to me, participants in the human round. My fellows, in the dim corridors, in our singular passage.

Oh, of course I want to touch them, but that isn't the important thing.

There will be one more present in my day—a long, exquisite dinner, courses brought by an elegant Thai waiter in the slimmest and sheerest possible shirt emblazoned with an electronically imaged Buddha, the splendid food wrapped, layered, revealing itself a nuance at a time. The restaurant prides itself on the eccentricity of its presentation; nothing matches at all, each plate and fork unique, and when the meal's over I'm brought a finale of brandy in a strange, hand-blown glass whose stem is a golden, rayed sun. Holding the delicate thing between two fingers, lifting to my mouth the fragrant fire, I feel possessed by the things of the day, the perfect birthday, somehow both celebratory and deeply mysterious, quite alive and somehow still full of ghosts, presences both actual and imagined, historical, overheard: blooms, fruit, gestures, voices, rain, skin. I feel singled out, somehow, plucked out, lifted into a community of delight.

All material, all bodies. The Madonna of the fourteenth-century Italian painter Sassetta, James Elkins reminds us in *What Painting Is,* "is made of gold powder, red clay, calves'

hooves, egg yolks from eggs produced by 'city hens' (as opposed to 'country hens'), oils, minerals . . . old linen and marble dust."

A paradox, that all this light in front of us, on these canvases and panels of wood or copper, is not light, but an image of the fleeting world made out of sold stuff, emulsions of clay and minerals and tinting materials suspended in oil. Thus it is light built of earthly things, and in this way somewhat like ourselves, both solid and ethereal at once, both heavy matter and energetic quickness.

A painting doesn't especially seem like an object, since we seem always to be looking through it, into it, rather than at it. This is the sublime joke of Cornelius Norbertus Gijsbrechts's *The Back of a Picture,* a painting which represents a painting with its back turned to us, so that what we see is the stretched backside of the canvas, its rough and lustrous gray, its raveled edges, plain prose. In a way there is nothing here to see, despite the bit of paper emblazoned with a number—36—attached to the upper-left-hand side of the canvas. But that is, in another way, the point, that whatever image this painting might bear on its "other side" is forever denied to us, a permanent mystery. And if we turned this image over, to solve the problem once and for all, and get to the other side, what would we see? The backside of a stretched canvas, of course.

Or we could say the painting points to the here and now: beautiful blankness, the plain, everyday virtue of the back of a canvas, a good ordinary thing joining the sturdy republic of things that Dutch painting is—and reminding us, at the same time, that even a painting, even this painting itself, is another thing.

Of course the solidity of things can be oppressive, too.

"Our houses are our biographies, the stories of our victories

and defeats." My particular defeat is in the attic, which is crammed to the rafters, grown impenetrable, layered like those cave strata in which paleontologists unearth the stacked evidence of inhabitation.

Though Wally and I streamlined our auction-house possessions when we left Vermont, we didn't get rid of everything; there was sentimental stuff—his high school yearbooks, jars of coins and buttons and badges, memorabilia from this year or that, pack-rat collections. My old journals and notebooks, little magazines I'd published poems in years ago. Useless things too handsome or interesting to part with: all the components of a disassembled porcelain doll, a large frame painted by some dreamy nineteenth-century hand with water lilies in moonlight. Whatever didn't fit in this house found its way up there, and new things came to occupy it as well, and old clothes. After Wally died, there was something distinctly unbearable to me about the prospect of cleaning it out, of sorting through those boxes that weren't just about my life with him but also his life before I came along. His brother's old paintings, his large collection of albums by women country-and-western singers, his full-length raccoon coat, circa 1925, worn, in its heyday, to Dartmouth football games—what would I ever do with that stuff?

I am no less culpable. There is my stash of salvaged wood—wide, nineteenth-century boards, doors from old Cape houses. Books, gardening magazines, cans of paint, carpentry supplies, quilts, paintings I've no place to hang, baskets, picture frames. At some point, the mass congeals, no longer individual things but something with a weight and presence of its own, heavy as history.

Add to that, then, old manuscripts and notebooks of Paul's, a novel on disks so big and clunky I doubt we could find a com-

puter anywhere to read them. Posters from readings he's given,
old cassette tapes, sheet music from his secret career as a composer of liturgical music. My friend Michael's old journals, smoke- and water-stained when his apartment burned. An antique leather suitcase left—by whom? Twice we've rented the house and our tenants left their marks on the attic, too, doing their bit to add to the assemblage. One winter not long ago, the house empty, pipes drained, visiting mice found a sack of birdseed I'd forgotten and threw a bacchanal worthy of the Cities of the Plain. Now when one threads a careful path through, the attic accumulation crackles with the sharp hulls of split and discarded sunflower seeds. Paul found a mass of them stashed inside a black boot he went to put on one snowy day.

I cannot go up there without defeating my own spirits. I approach it when I must—to retrieve an electric fan or find a putty knife—with trepidation, and hurry out. Recently I decided this would be the year for change, for the bracing, cleansing confrontation with this daunting heap, hostile, mocking, eroding my will. Each element of the mass up there is interesting in itself; taken all together they overwhelm and shame. I find myself wondering what I'd feel if all of it were suddenly gone, somehow vaporized or spirited away. Would I miss any of it? Would I be relieved?

I have made progress, but only in one strip of the room nearest the door; behind the stairwell opening looms a solid, intricately balanced wall of things. I look at them and I'm not sure whose things they are.

Such an accumulation makes one want to be free of possessions, unencumbered; the quick self wishes to flee from the heavy baggage of time, the clanking and clattering weight stacked so

precariously, and so difficult to sort out or discard when each object, taken one at a time, comes with a history, a set of associations. Each is a kind of trigger point of memory, as if packed within it were the very stuff of time. "Space," Bachelard says somewhere, "contains compressed time. That is what space is for." How sweeping and unmistakably French, that thrilling intellectual pronouncement!

Space, which lacks the evidence of time, where all the objects seem to have happened at once, seems two-dimensional, lacking in depth. Of course I want to live in space that is honeycombed with the past, and not merely for sentiment's sake—those things that are full of the passage of time point to the future, too, by means of their persistence, their staying on.

The issue, of course, is balance. A familiar problem in another costume: the desire to be solidified, in relation, bound to people and to things in time, here expressed in my house and its groaning upper regions, its poor old crowded brain stuffed with memory. I want to live with my lover and my animals in a house stratified with our collective histories.

And of course I carry, permanently, the contradictory desire—to be free, open to the winds, awash in light and air, unbordered. Half a block from this house is the harbor, its wind-raked Atlantic expanse; that shoreline's a perpetual image of change, and of freedom. Nothing stays there long, be it shell or seawrack or seal, dinghy or beached boat. The exact edge where water touches land is never still, constantly revising itself, expanding and contracting. Alice Fulton refers, in a recent essay on poetics, to a mathematician who pointed out that the coastline of Britain actually couldn't be measured, it was so intricate in its patterning, the little curvings of each place where the water touched shore paralleling, in form, the larger inlets and promontories of coast. And mobile, too, instable. The open ho-

rizontals of coast are the figure of fluid and aerial being—not rooted, not grounded, not held down or back by attachment. That's why Wally's ashes went into the grand expanse of salt marsh at Hatches' Harbor; here was endless mutability, receptivity, change, the wide mirroring water full of sky and cloud.

The dreamed-of balance: to be rooted in the house, in comfortable domestic alliance, in relation—and to have one's freedom of association, too, weightless, with the quick mobility of air or fire. Both solid and spirited, both fixed and unbound.

Or perhaps another sort of balance, maybe a simpler one to achieve: to decide how much is enough. To arrive at an acceptable degree of clutter by cleaning out the attic.

I went back to the Met to pay another visit to Jan de Heem, my third trip in as many years. I traced my way back through the rooms—through the centuries—toward the familiar glass case, only to find the painting gone from its familiar place. A moment of disorientation. I asked the guard, who thought a bit (much more accustomed, I'm sure, to questions about Vermeers or Caravaggios), then told me the picture had been moved to a room a few numbers away.

And there, chambers of portaits and landscapes away, on one of those soft green walls softly lit with daylight from the frosted skylight above, it was. Wasn't it? In truth it seemed so different I wasn't sure at first. Now the picture was hung on the wall, which shifted one's relationship to it a little; I'd liked bending over this little, particular treasure; the act of doing so tended to make the rest of the museum (and the museum-goers) go away. Now one was aware of other pictures beside it; now it seemed less a sphere unto itself.

And, of course, I had been reimagining my picture; I'd described it to myself, while I was away from it, and description is

always an act of interiorizing what we see. Description delineates the world, yes, but in doing so it informs what's seen with ourselves, our ways of seeing. I felt the picture itself had shifted somehow—it was convivial, atmospheric, a lovely little interior flushed with a glow of warmth or pleasure—but it lacked that riveting sense of pulling me in I'd experienced before, the sense that so much was at stake within the realm of the picture, which was tiny but in no way diminutive.

To make matters worse, even the name had been changed! The placard mounted beside the painting now read *Still Life with a Glass,* a title less appealing to the senses, and thus less satisfying. Not only had I reinvented the painting in my memory, making it more my own over time, but the actual painting seemed to have moved farther from me, its new title carrying it to a farther distance from my memory of encountering it.

There is a poem of Cavafy's I love, only five lines but nonetheless central to his work. Here is "In the Same Space," in Edmund Keeley and Philip Sherrard's translation:

> *The setting of houses, cafés, the neighborhood*
> *that I've seen and walked through years on end:*
> *I created you while I was happy, while I was sad,*
> *with so many incidents, so many details.*
>
> *And, for me, the whole of you has been transformed*
> *into feeling.*

What memory does, what long habitation does, Cavafy proposes, is art—or at least it does exactly what art does, which is to take the world within us and somehow make it ours, through description, through memory, through the act of saying the world, saying (or painting!) how we see.

The painting is a perfectly splendid thing in itself, but my re-invention of it shines in my memory nonetheless, and I would like to think that Jan de Heem would approve of this; it seems appropriate to the project of still life, somehow, that I have re-cast this image of the world in the light of my own affections. That is all memory can accomplish, or hope for.

Where is Jan Davidsz de Heem now?

On the wall. In the book.

Of what country is he a citizen?

Light's commonwealth.

What does it read on his passport?

Light without borders and everywhere the same: planetary, equally milky or clear, shadowy and weighted, moist and dif-fuse, inquisitive, kind.

And no need of one, since now he travels everywhere, in the unbounded commerce and intercourse of light.

And where does he reside?

Unfixed, unfixable but fixed forever, in the movement of light intersecting a thin slice of lemon, the translucent, honeyed cells in which all of time is stored, in which starlight has made its long journey into flesh, into pulp and sugars, to become this irreplaceable sudden moment: clear yellow, reverberant, sour, quickening the senses, alive. Fragrant? Nearly so. Offer the senses enough evidence, enough of the information we need, and we'll complete the rest. This timeless bit of fruit is made only of ground clays suspended in oils and varnishes, oils that

have dried now. Only glazed cloth, but what the mind sees, what the tongue apprehends, is fresh, quick, squirting forth its juices.

And where does he worship?

On the lip of the pitcher, the tip of the knife.

I know that all of this might be taken as precious, a hymn to so much useless beauty, in an hour when the notion of beauty is suspect—when it seems to suggest a falsely bright view of the world, or a narrow set of aesthetic principles related to the values of those in power, an oppressive construction.

And indeed it might be so, were what matters about still life simply confined to the museum, if these paintings were solely self-referential, removed from the world, an elaborate language of hymns to themselves. If they elided death, the fact of our quick transits in time.

But still life is about the given. And in both senses of the word: that which is always at hand, which we take for granted, and that which is offered, proffered, which the world provides for us, the now. At hand: to be grasped, to be lifted to the mouth.

It is an art that points to the human by leaving the human out; nowhere visible, we're everywhere. It is an art that points to meaning through wordlessness, that points to timelessness through things permanently caught in time. That points to immensity through intimacy. An art of modest claims that seems perennial, inexhaustible.

Deep paradox: things placed right next to us, in absolute intimacy, yet unknowable. Full of history, but their history is mute; full of associations with particular people, moments, gestures,

emotions, and all those associations unavailable now, nothing left of them but a residue, as if accumulated feeling could dissipate into the air, into a haze or vapor of human presence.

And perhaps that's another of the paintings' secrets: they satisfy so deeply because they offer us intimacy and distance at once, allow us to be both here and gone.

Here and gone. That's what it is to be human, I think—to be both someone and no one at once, to hold a particular identity in the world (our names, our place of origins, our family and affectional ties) and to feel that solid set of ties also capable of dissolution, slipping away, as we become moments of attention.

We think that to find ourselves we need turn inward, examining the intricacies of origin, the shaping forces of personality. But "I" is just as much to be found in the world; looking outward, we experience the one who does the seeing. Say what you see and you experience yourself through your style of seeing and saying.

The great Dutch still lifes of the seventeenth century are full of individual differences—not just the bravura repositioning of those ubiquitous lemon peels, but more subtle negotiations with qualities of light, with reflection and transparency and opacity. Modes of seeing unique to Balthasar van der Ast or Rachel Ruysch, Clara Peeters or Pieter Claesz. And yet there is no sense here of a drive toward personality, of marking the work with an unmistakable sense of individuality. The work *has* this unmistakability about it, when one gets to know the signatures of individual painters, but I do not believe that was their goal— their attention was turned outward, toward that which was to be represented. There is an odd quality of egolessness about these pictures, when one takes them as a whole; they represent a

grand, collective visual enterprise, a kind of a team inquiry into reality, and they abandon the stuff of personality in order to look deeply at the world. In this fiercely burning gaze, personality seems burned away. (One can see exactly where this practice of abnegation ends, in Rembrandt, where suddenly the glorious, entirely idiosyncratic Self is everything.)

But in my beloved still lifes, this hasn't happened yet; the painter's overt attention is turned toward the world. Who would have thought an act of relinquishment could be so lavish? The self is emptied into things, and thus the things shine with an astonishing life.

Someone and no one. That, I think, is the deepest secret of these paintings, finally, although it seems just barely in the realm of the sayable, this feeling that beneath the attachments and appurtenances, the furnishings of selfhood, what we are is attention, a quick physical presence in the world, a bright point of consciousness in a wide field from which we are not really separate. That, in a field of light, we are intensifications of that light.

I live in a capital of light.

Walking down our street toward the harbor, Paul and I had just turned the curve that opens onto a view of the sea when we heard some people crying out, *Oh!* They'd been struck, compelled to exclaim, by the quality of the light, which was at that moment doing an extraordinary thing. The lamps on the pier had just come on, since it was almost sundown, but a brilliant, warm light from the descending sun had struck the sides of the boats tethered just above a long expanse of slate-gray water. One in particular seemed to have been singled out: a white boat with rusty stains on its flanks, bathed in the warmest rose light. It seemed chosen by the sun for something akin to cherishing.

In the warm moment of that light's zenith, no one could help but exclaim; the light simply called up in an involuntary reaction.

Though we hurried down to the edge of the water, that glow was so transient that by the time we reached the edge of the sand it was really a remnant of itself—quite nice, but not something that would make us cry out, especially as we've lived with it for years.

We turned our attention toward something else—a cloud, some gulls—and by the time we looked back at the boats the sun was gone completely, nothing left but a rusty white boat to show where the splendor had been.

Later: moonlight on the water, a liquid gleaming path, funneling wider and wider in the distance, the inverse of paths on land, which narrow into the distance as if the sides of the way would converge, sometime. But the moon-path on the sea grows broader and more diffuse farther out, opening, eventually, into a wide swath of dull shimmer.

Later: Cafe Heaven, a restaurant we like, locally referred to as Heaven, for short, and thus engendering various jokes: Will we see you in Heaven? Shall we meet in Heaven? There's a votive candle in a clear holder on the white wooden table, and suddenly I think it causes Paul's eyes to flare, just like that lucky boat, so that one sees, suddenly, what was there all the time, and had only been waiting for light to find it out.

Stilleven, in Dutch; *la vie coite,* quiet or immobile life, in Old French; later, *nature morte. Stilstaende dingehn,* still-standing things.

Still life. The deep pun hidden in the term: life with death in it, life after the knowledge of death, is, after all, still life.

The darkness behind these gathered things—a living dark-

ness, almost breathing, almost a pressure against us—is the not-
here, the not-now; what we can see are the illuminated things
right before us, our good company. The space looming behind
them is the unknown of everything else—is, in other words, a
visible form of death, and therefore what stands before that
darkness stands close together.

What makes a poem a poem, finally, is that it is unparaphras-
able. There is no other way to say exactly this; it exists only in its
own body of language, only in these words. I may try to explain
it or represent it in other terms, but then some element of its life
will always be missing.

It's the same with painting. All I can say of still life must fi-
nally fall short; I may inventory, weigh, suggest, but I cannot
circumscribe; some element of mystery will always be left out.
What is missing is, precisely, its poetry.

Part of what that poetry is, I think, is the the inner life of the
dead, held in suspension. It is still visible to us; you can look at
the paintings and you can feel it. This is evidence that a long act
of seeing might translate into something permanent, both of
ourselves and curiously impersonal, sturdy, useful.

Of what use, exactly? As advocates of intimacy, as embodi-
ments of paradox, as witnesses to earth, here, this moment, now.
Evidence, thus, that tenderness and style are still the best ges-
tures we can make in the face of death.

WORKS CITED

Svetlana Alpert, *The Art of Describing: Dutch Art in the Seventeenth Century*

Gaston Bachelard, *The Poetics of Space*

Norman Bryson, *Looking at the Overlooked: Four Essays on Still Life Painting*

Constantin Cavafy, *Collected Poems*, translated by Edmund Keeley and Philip Sherrard

Alan Chong and Wouter Kloek, *Still-Life Paintings from the Netherlands, 1550–1720*

James Elkins, *What Painting Is*

Alice Fulton, *Feeling as a Foreign Language*

Federico García Lorca, *Collected Poems*

Louise Glück, *Proofs and Theories*

Zbigniew Herbert, *Still Life with a Bridle*

Marcel Proust, *Remembrance of Things Past*

Mary Heaton Vorse, *Time and the Town: A Provincetown Chronicle*

Ari Wallert, ed., *Still Lifes: Techniques and Style, an Examination of Paintings from the Rijksmuseum*

ACKNOWLEDGMENTS

My gratitude to Deborah Chasman, for *carte blanche,* and to David Coen and Edna Chiang for editorial support. To Carol Muske Dukes and my late friend Maggie Valentine for their loving attention to this book. To Bill Clegg for his friendship and hardworking endeavors on my behalf. To Paul Lisicky for inhabiting every sentence. And to the painters, of course, who have said, and go on saying, all that I cannot.